Lacy Sunshine's Sunshine Trolls and Hobgobbis Coloring Book

Volume 25

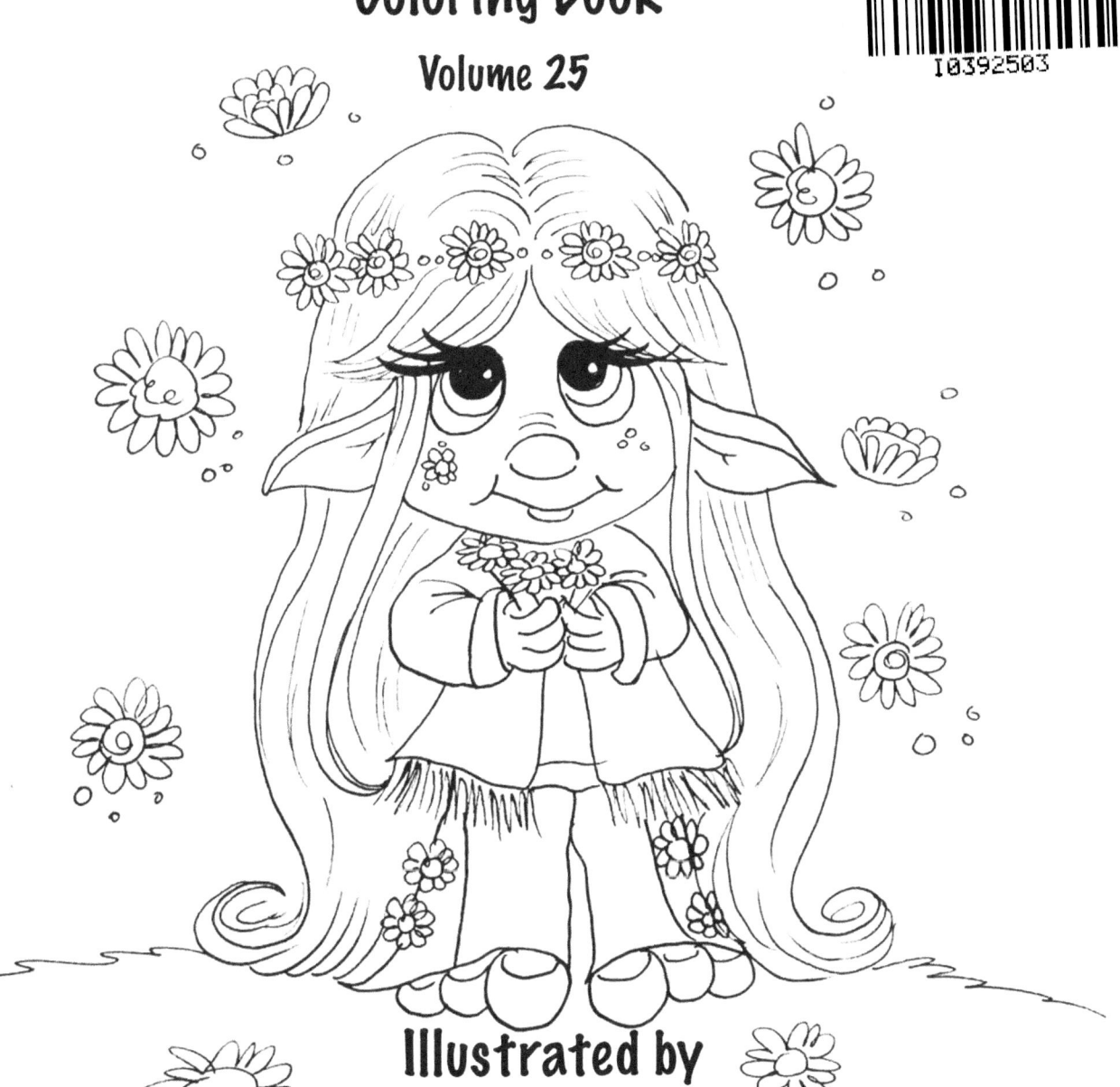

Illustrated by Heather Valentin

©Heather Valentin. Lacy Sunshine. All Rights Reserved.
No Redistribution. No Sharing Of Line Art On Social Media Sites
Without Artist's Consent.

Heather Valentin's Characters In Order of Appearance

Tipsykin Troll
Fifi Flirtydust's Hobgoggi Christmas
Fernkin Troll
Whoskers Hobgobbi
Daisykin Sunshine Troll
Rorykin Love Troll
Poseykin Troll
Fifi Flirtydust's Christmas Hobgobbi
Broomkin Troll

Delia Daisyfoot Hobgobbi Christmas
Bellbottom Troll
Rorykin Troll's Flower Pot
Angelkin Troll
Blisters Troll
Delia Hobgobbi- A Bunny Thing
Delia Daisyfoot Hobgobbi
Hippiekin Troll
Lotsa Love Hobgobbi
Dollykin Troll
Whoskers Bunny Hobgobbi
Tipsykin's Christmas
Jamkin Troll
Broomkin's Pumpkin Troll
Topsy Troll
Tiny Eveningpuff Hobgobbi
Loveykin Troll
Penelope Willows Hobgobbi
HollyKin Troll
Quicksilver Hobgobbi
Rorykin's Christmas Spirit

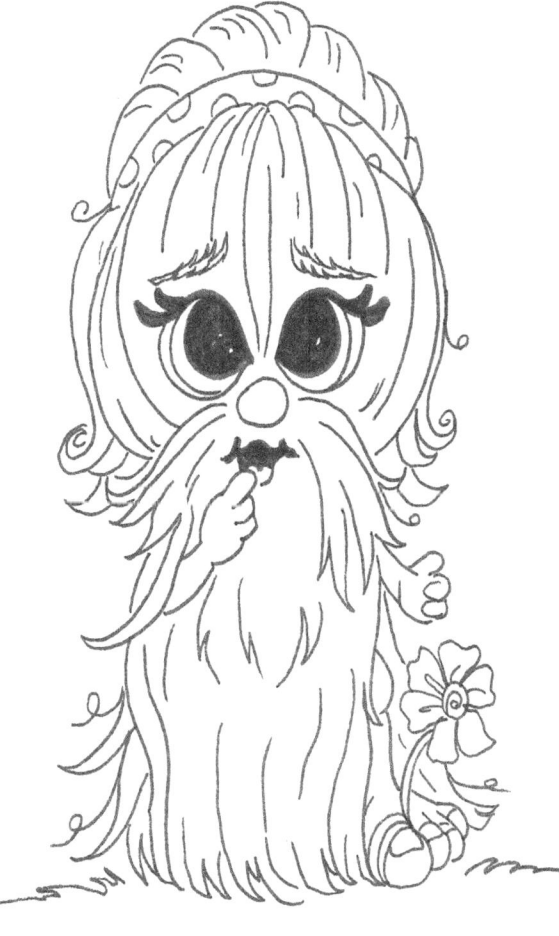

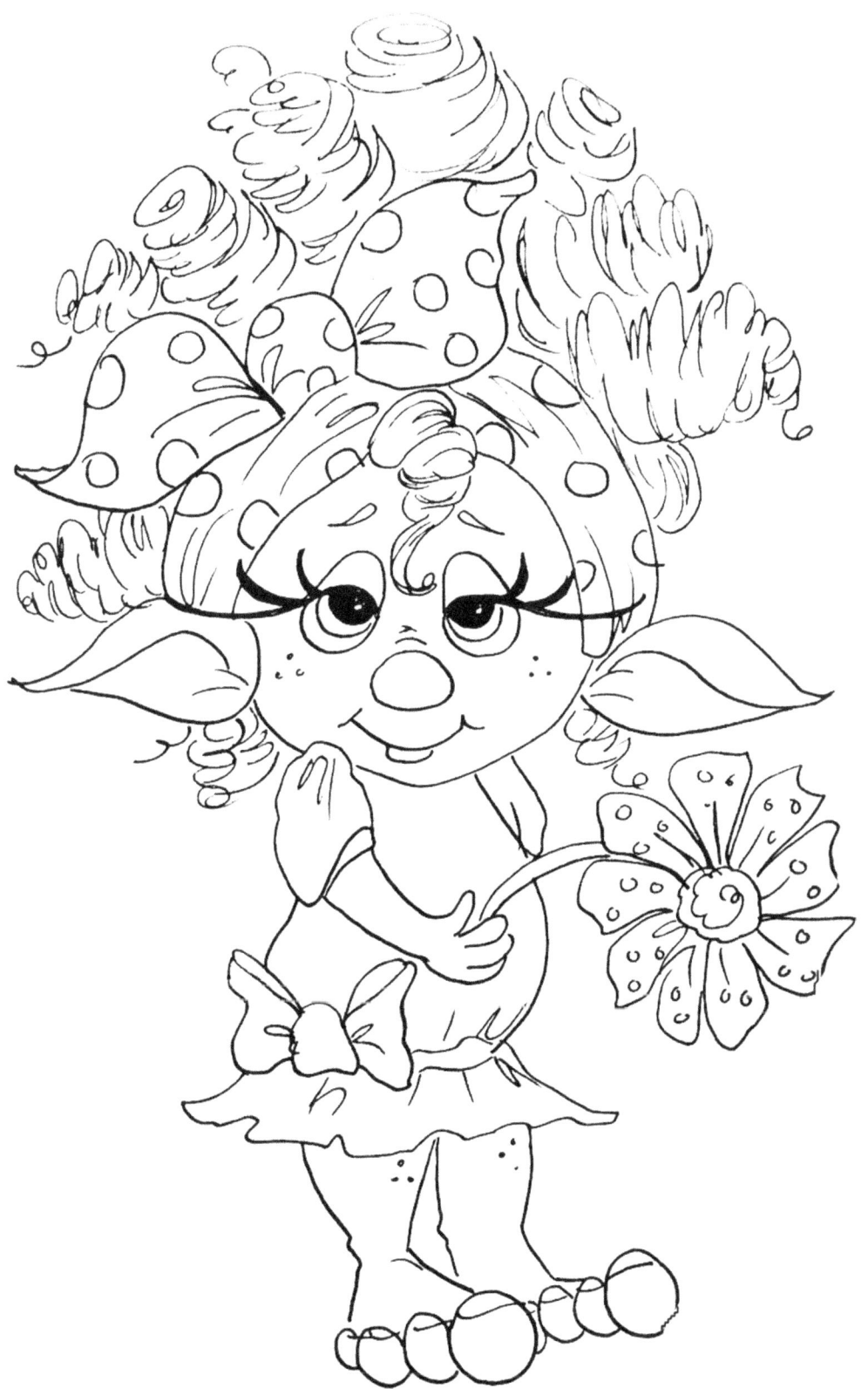

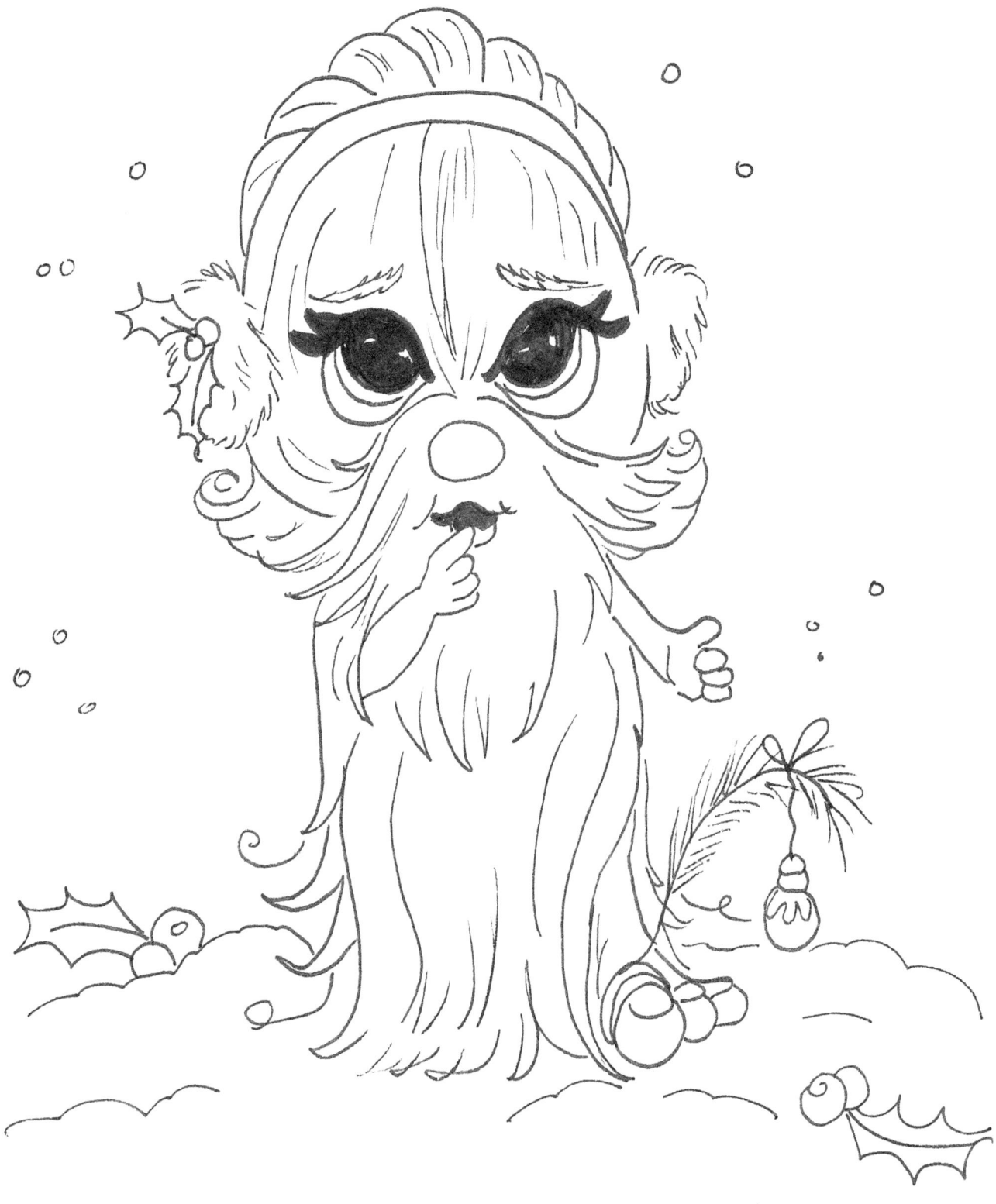

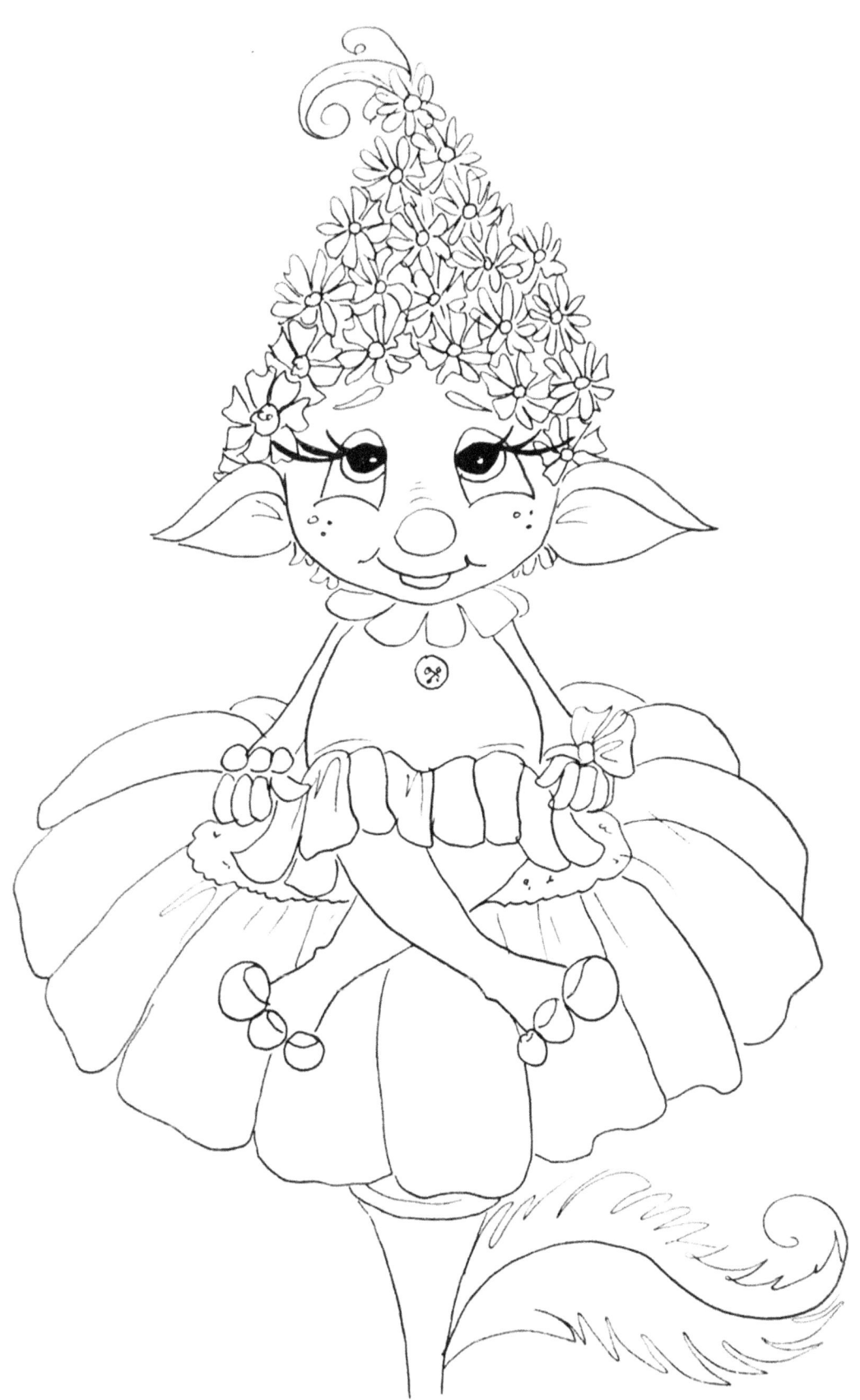

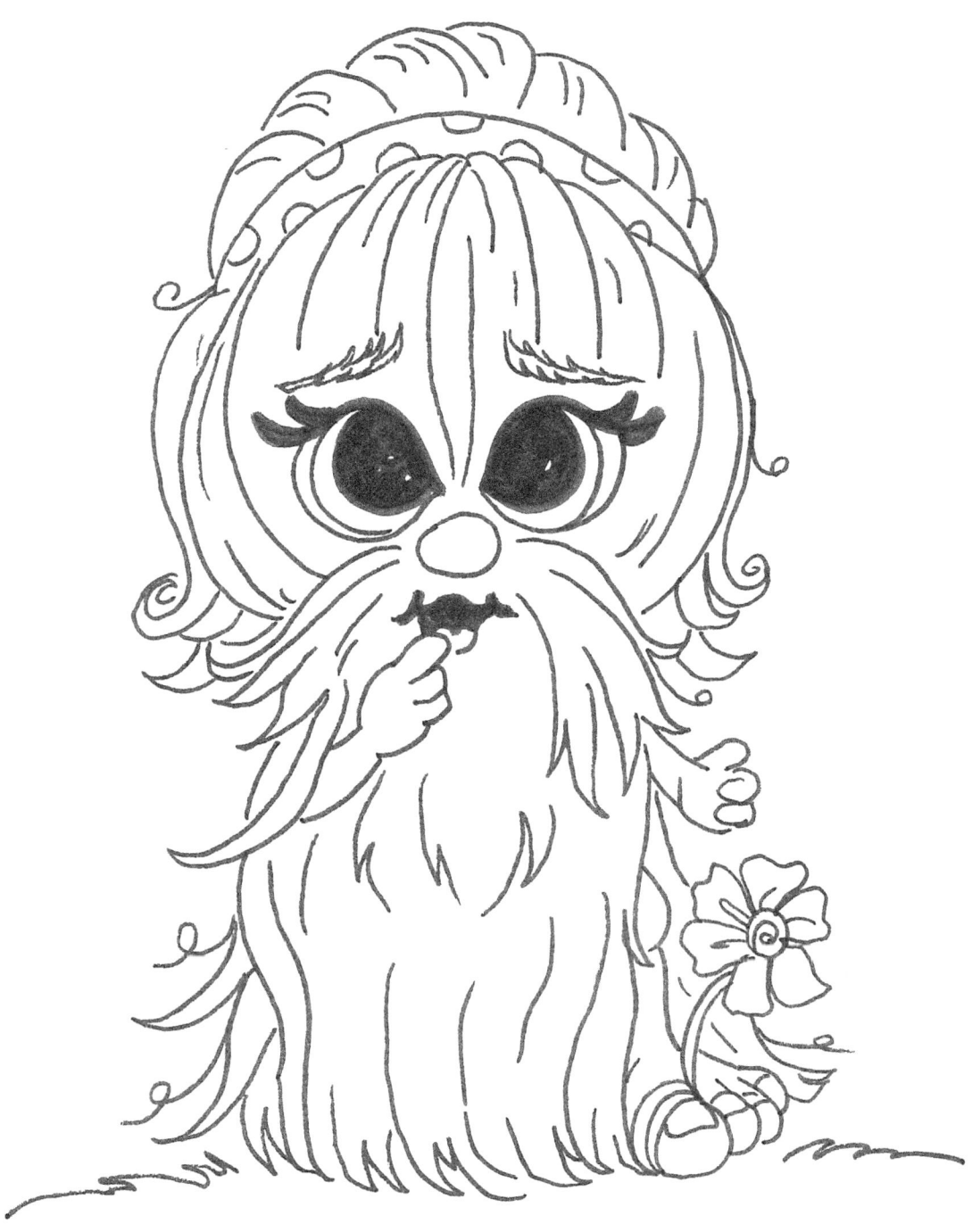

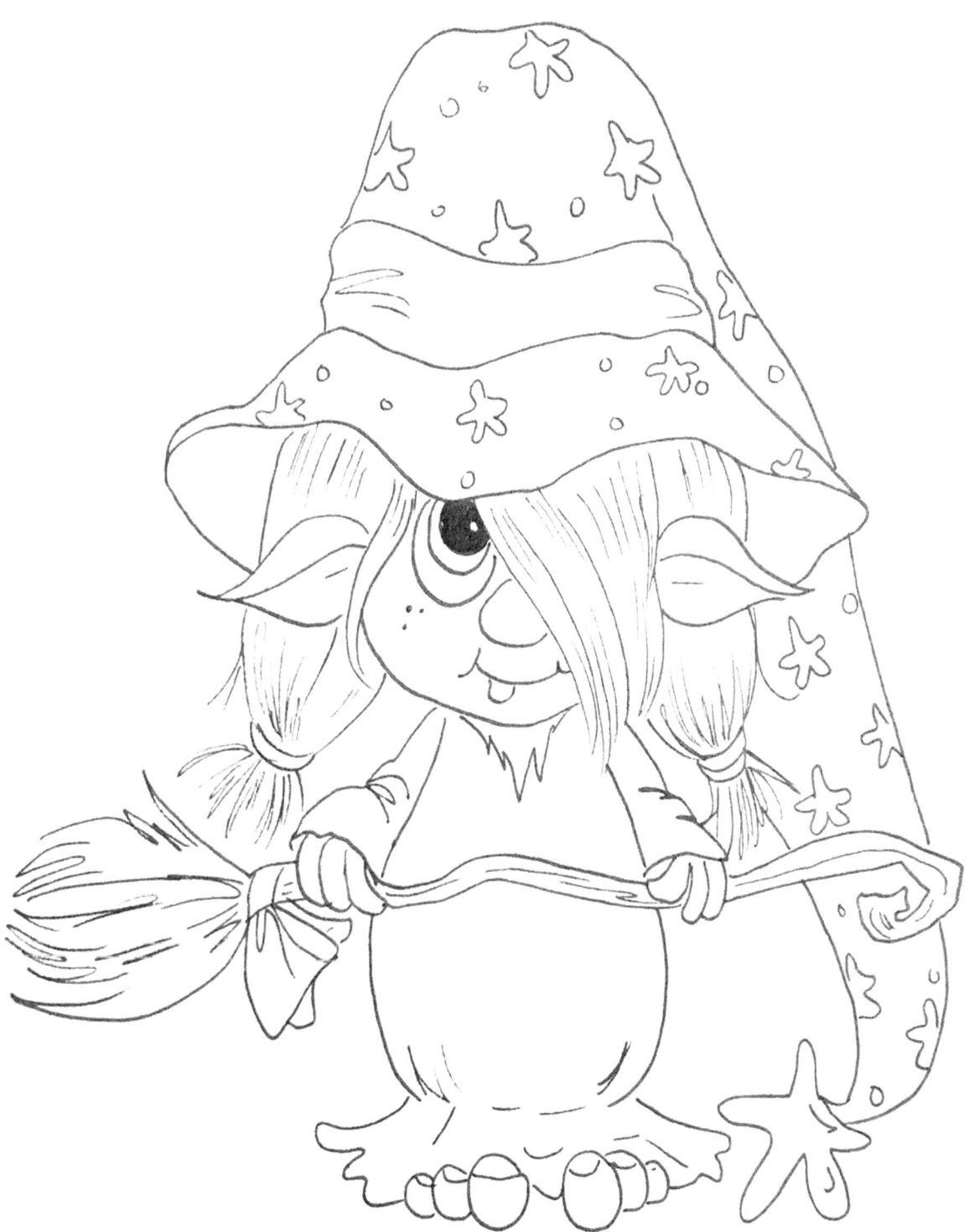

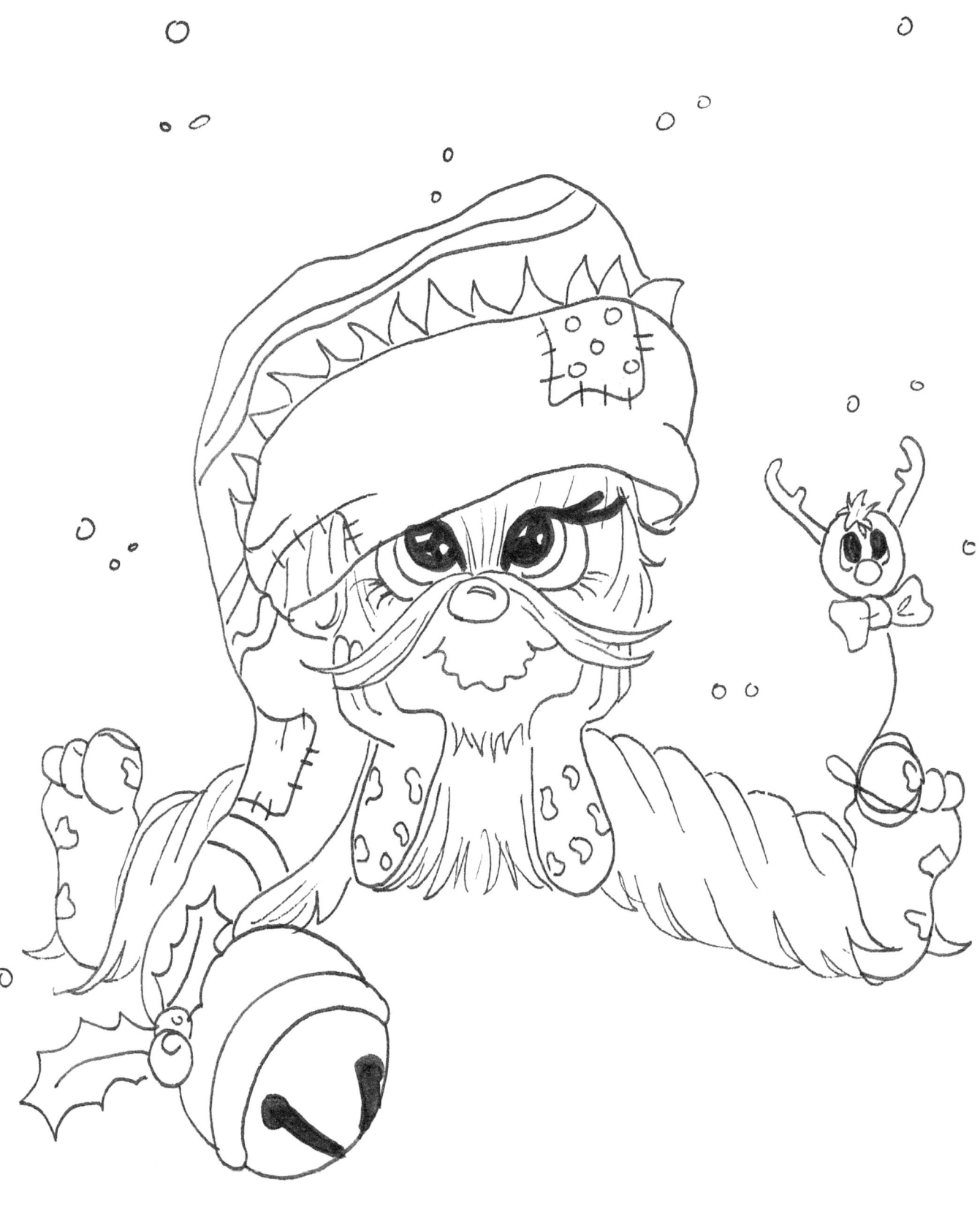

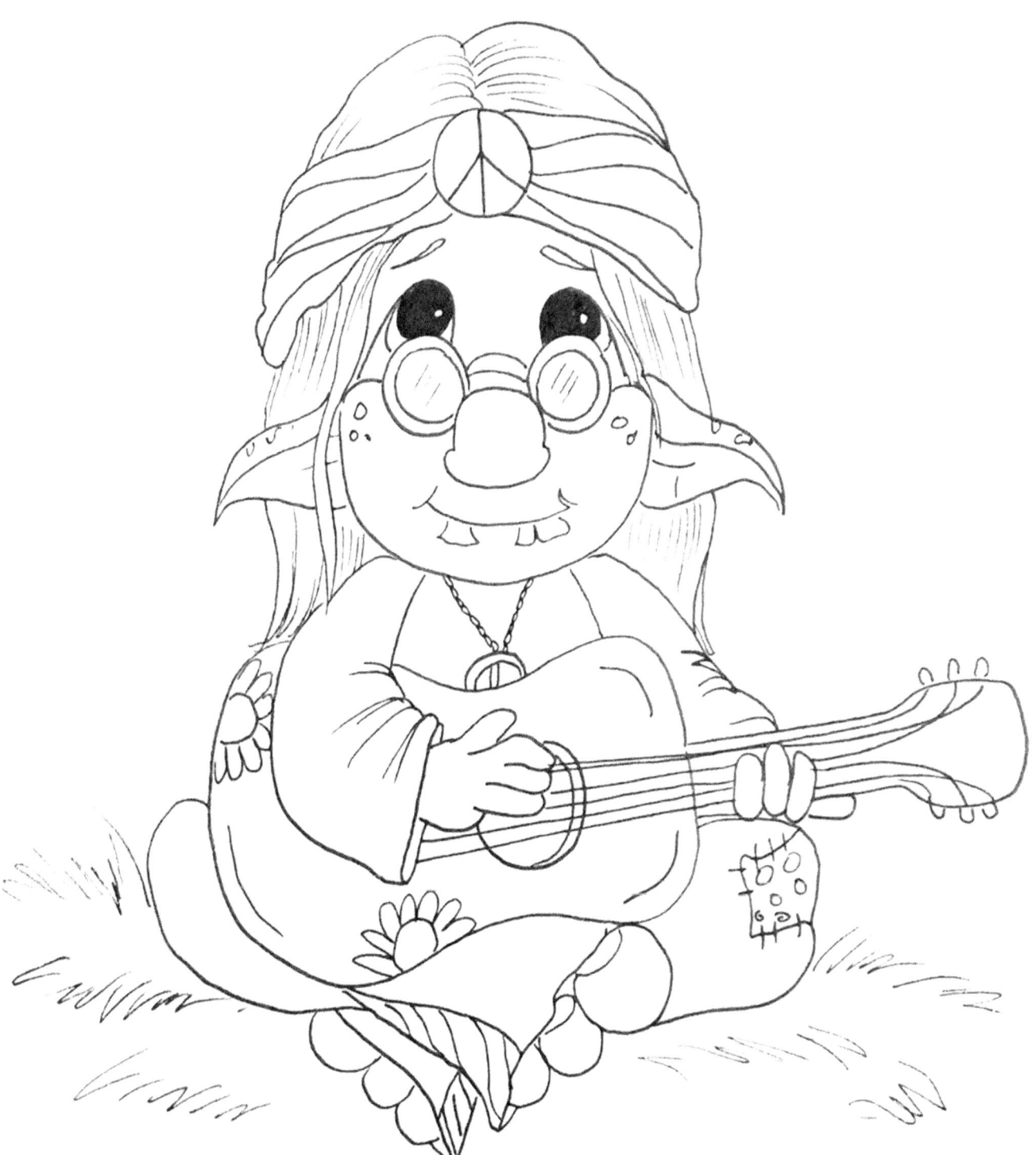

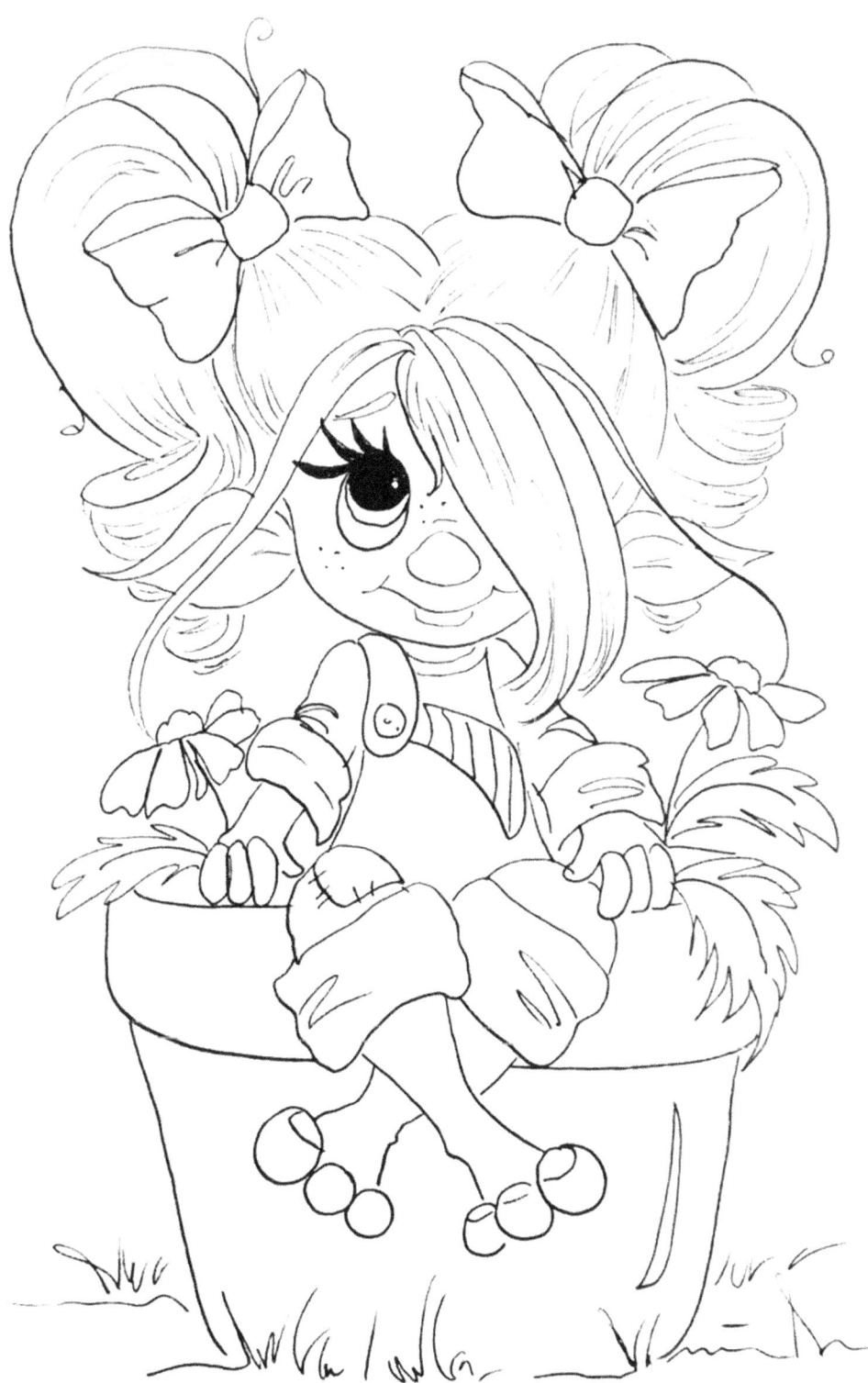

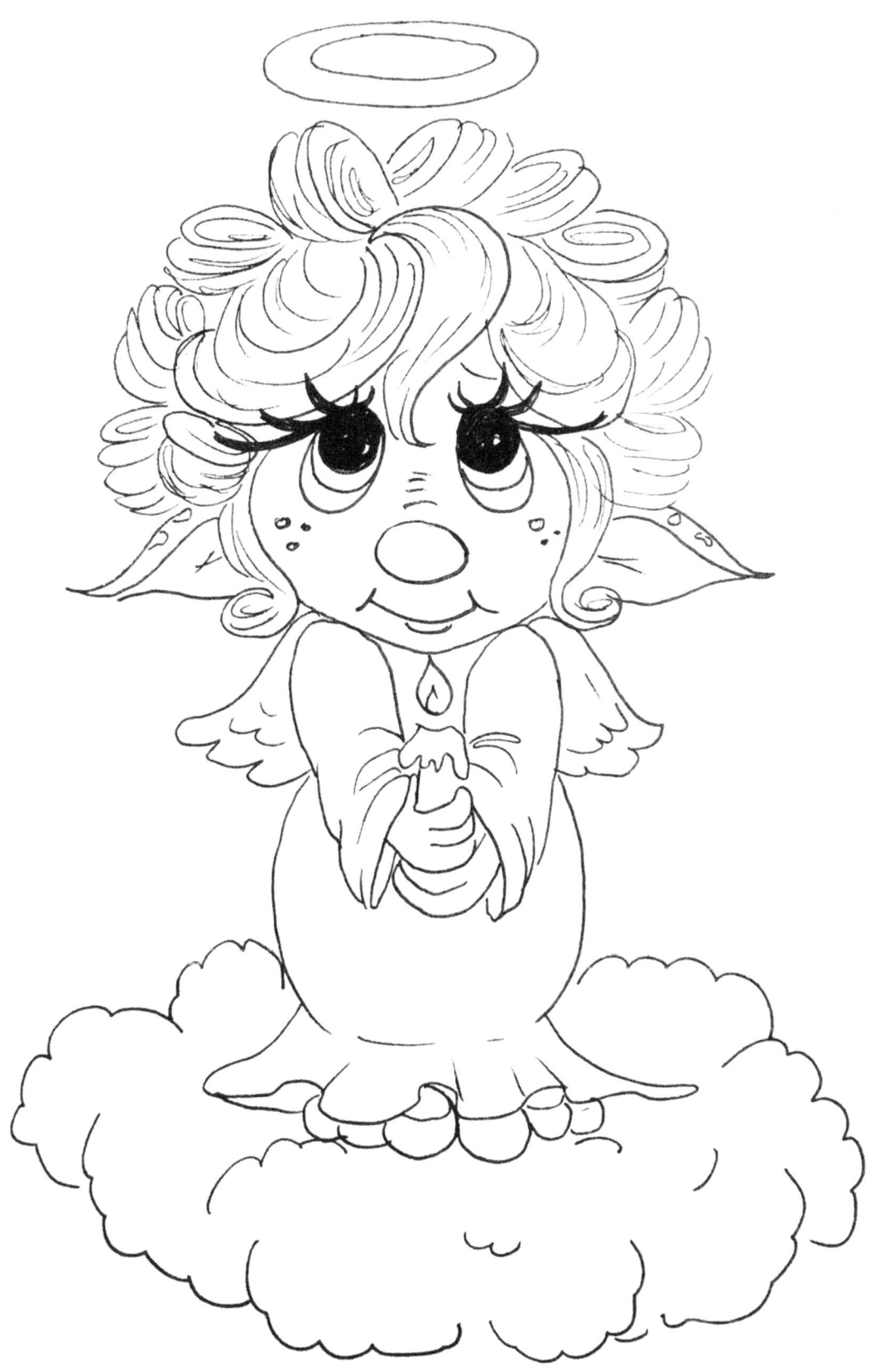

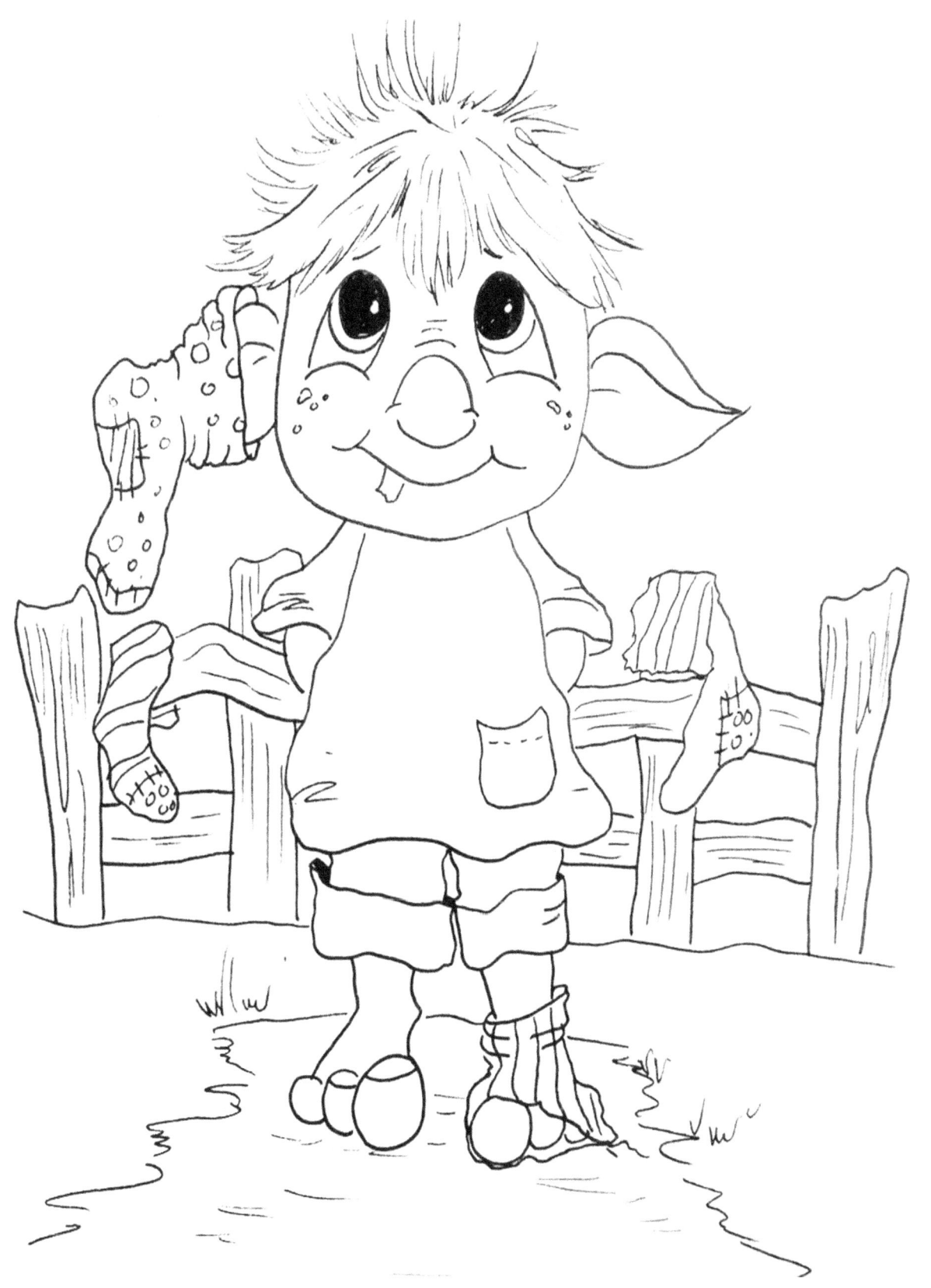

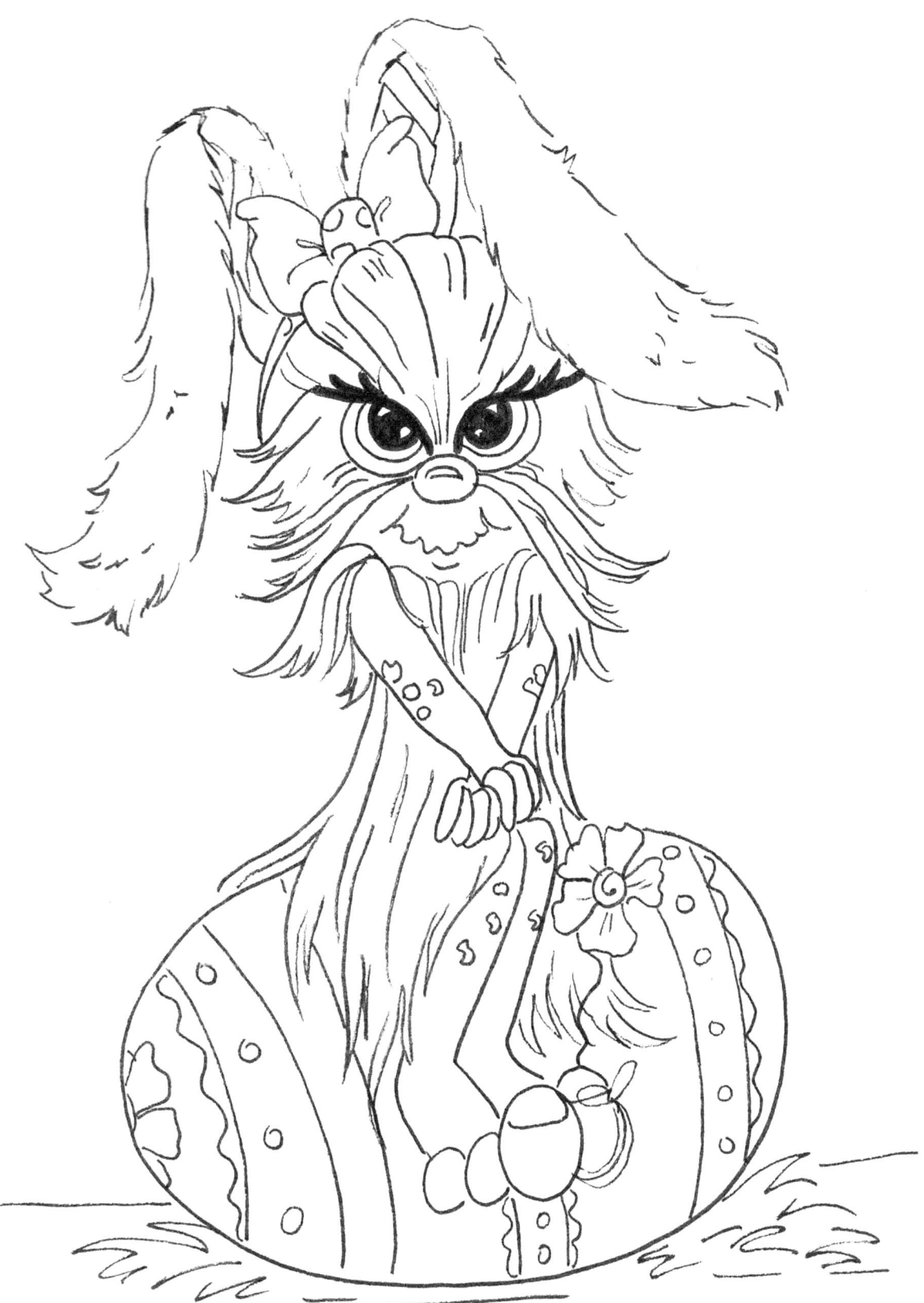

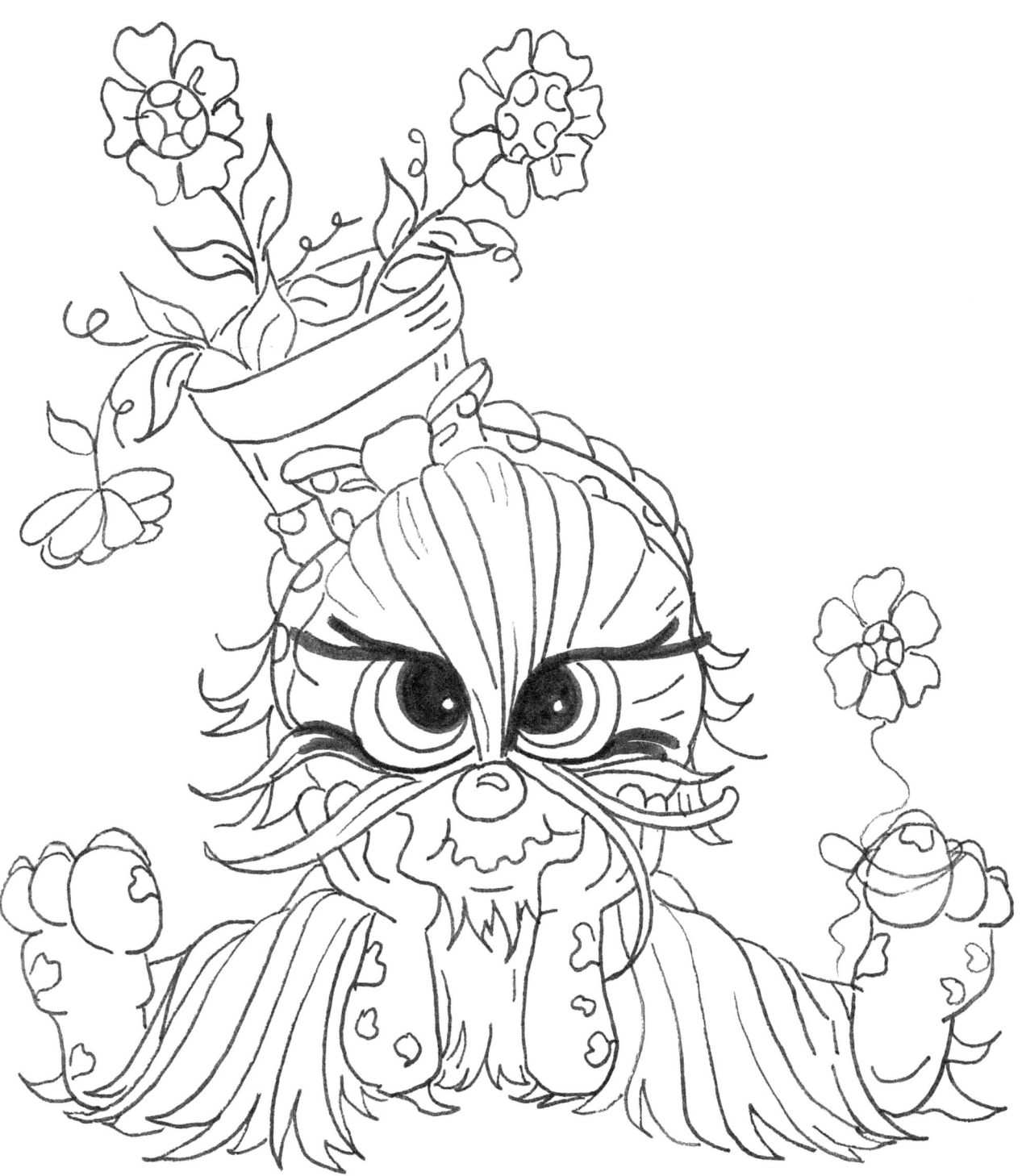

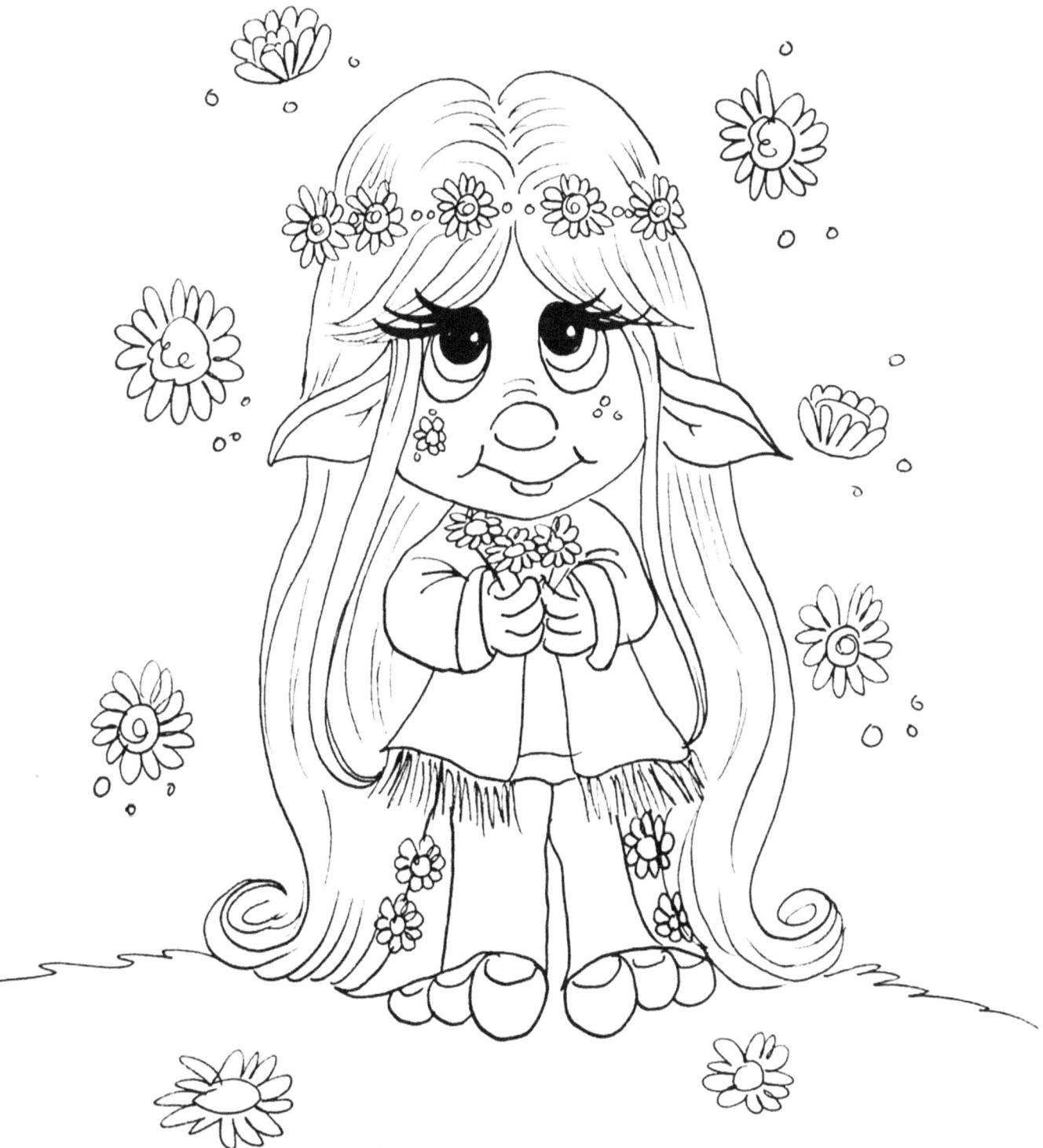

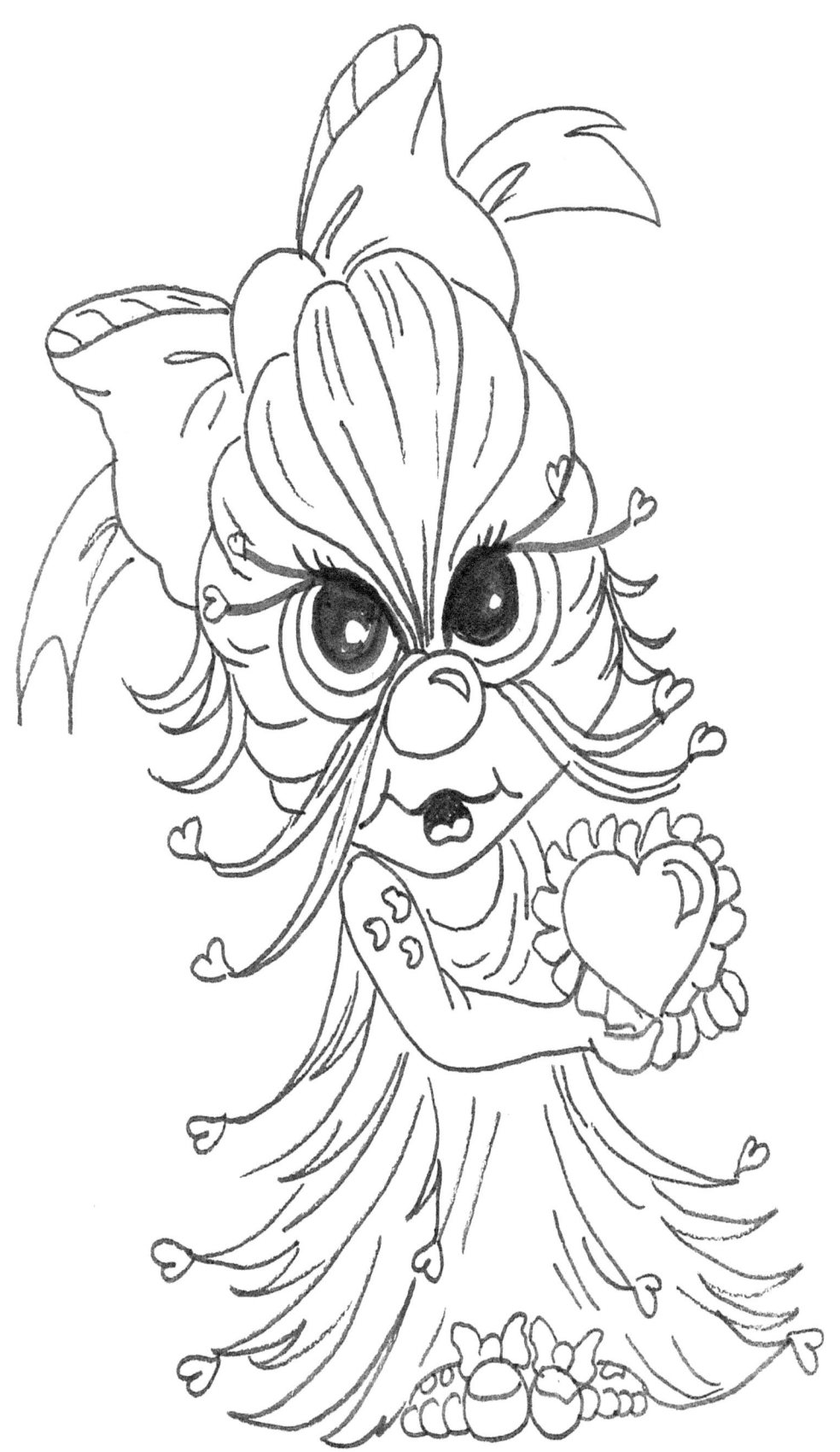

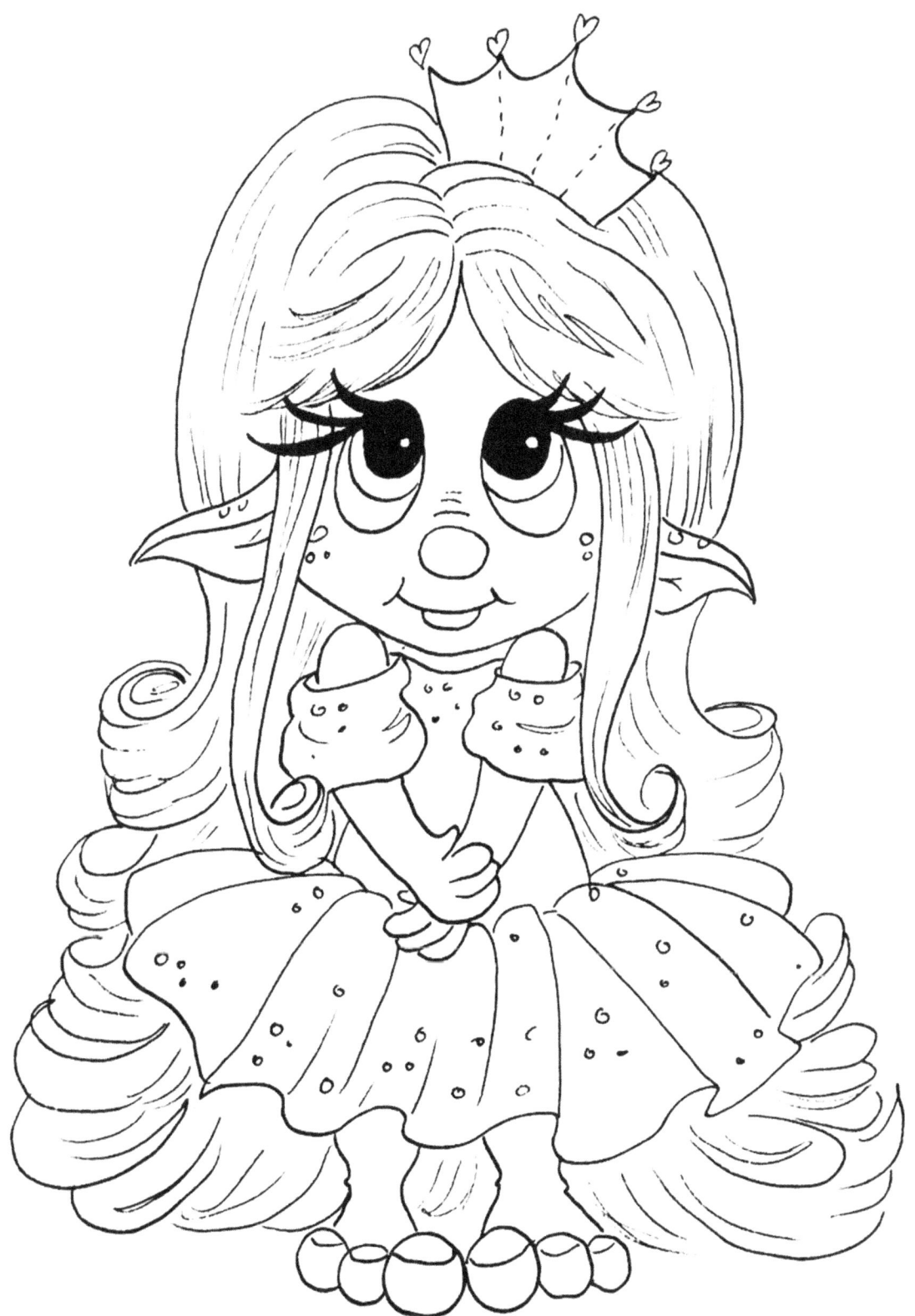

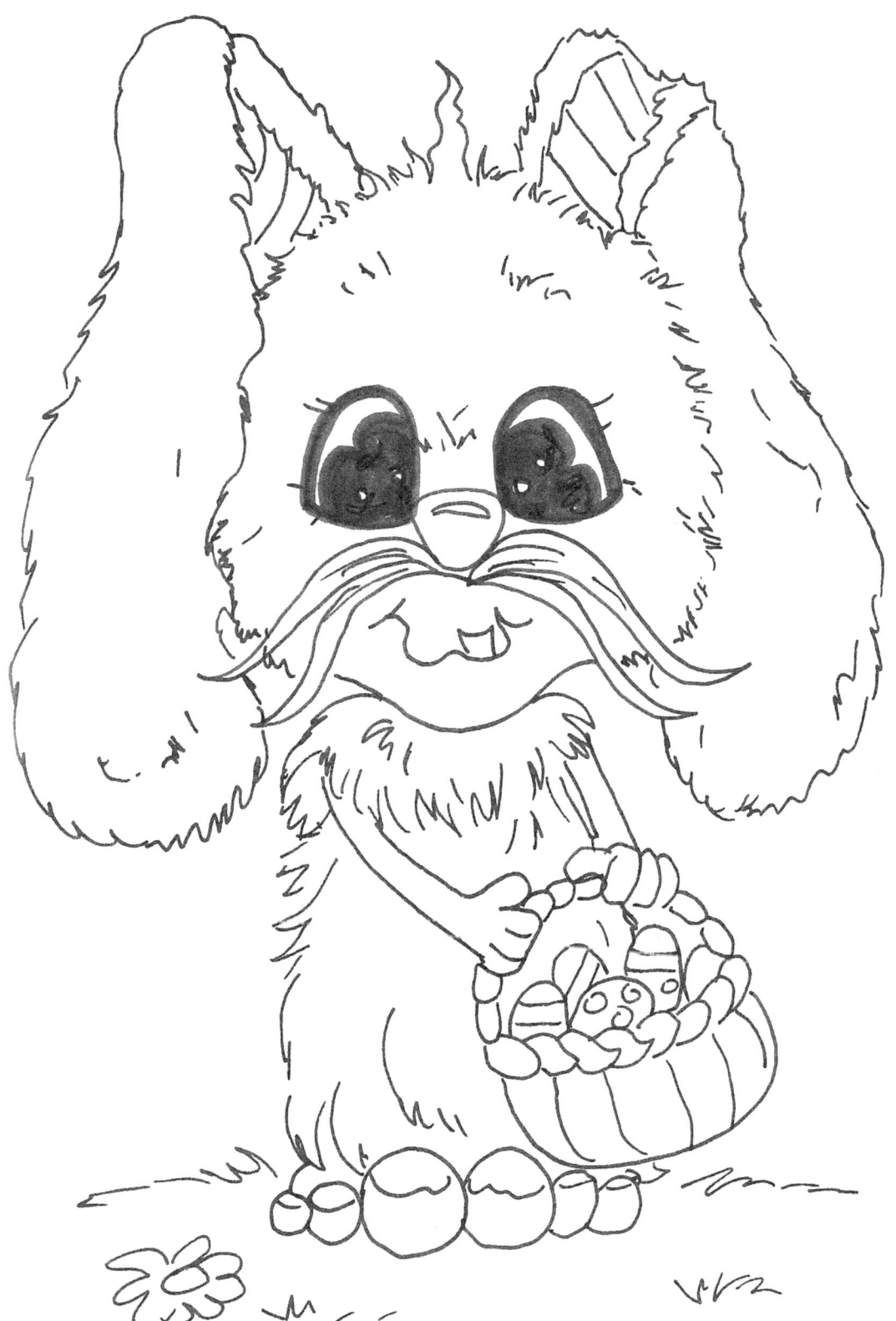

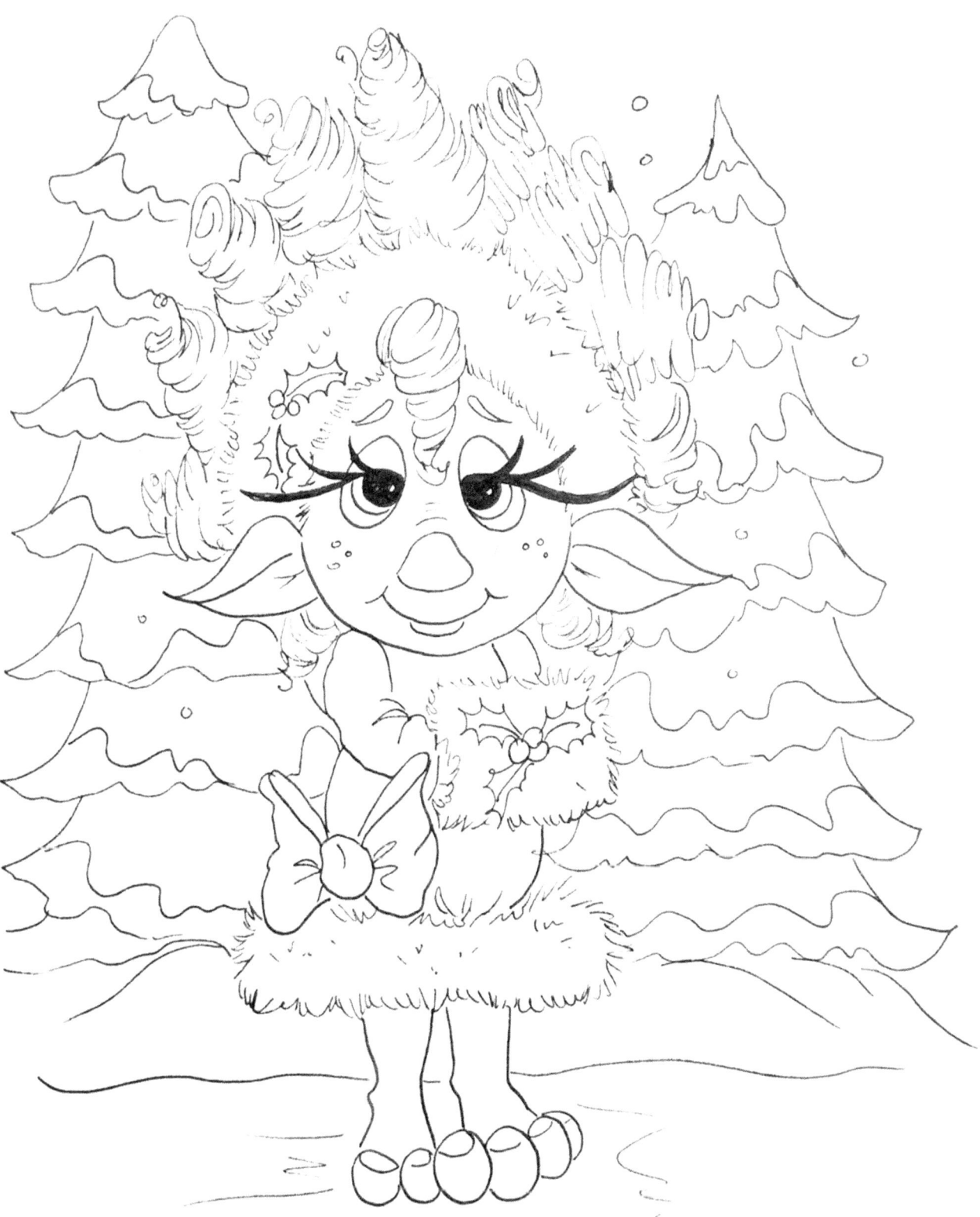

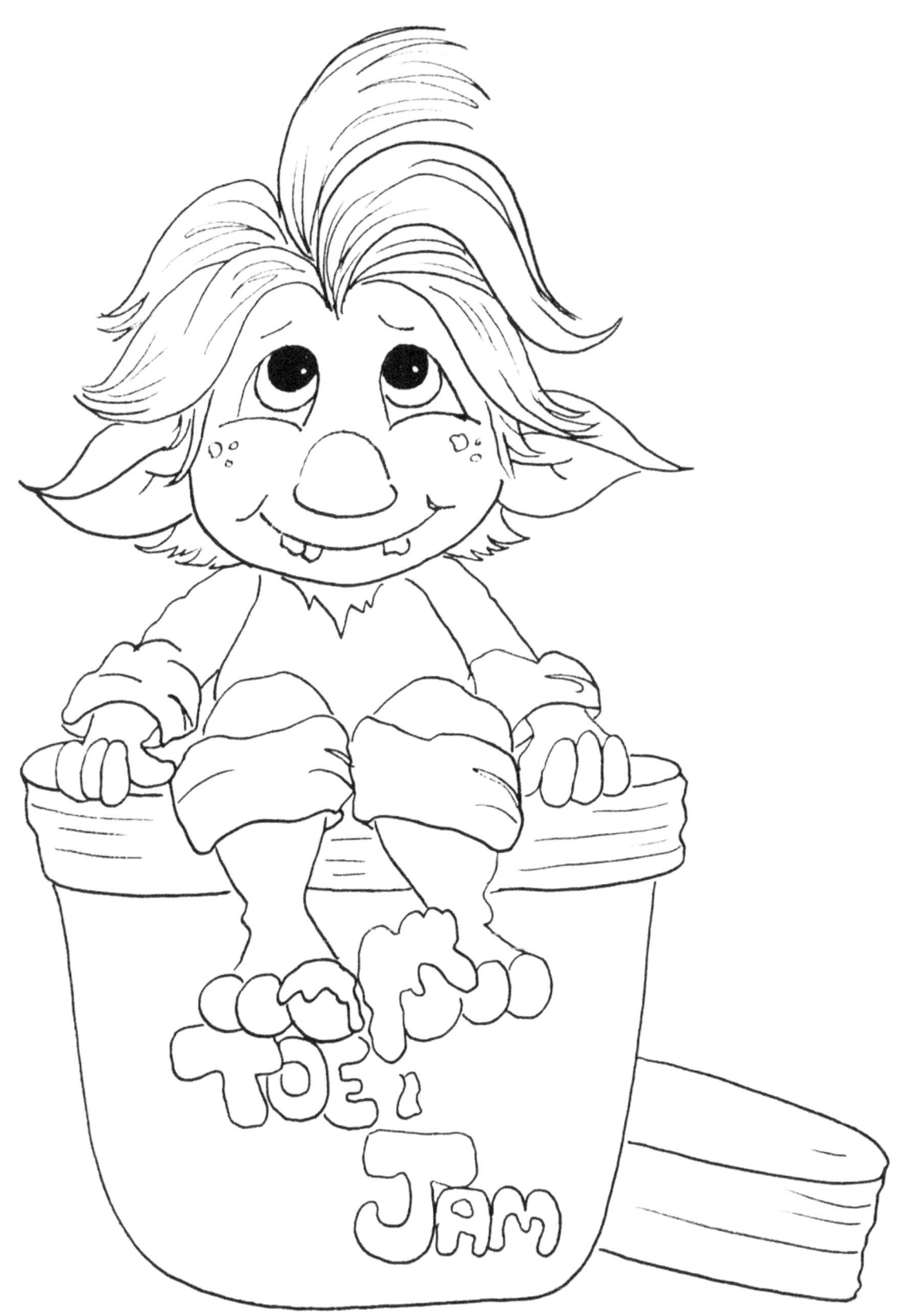

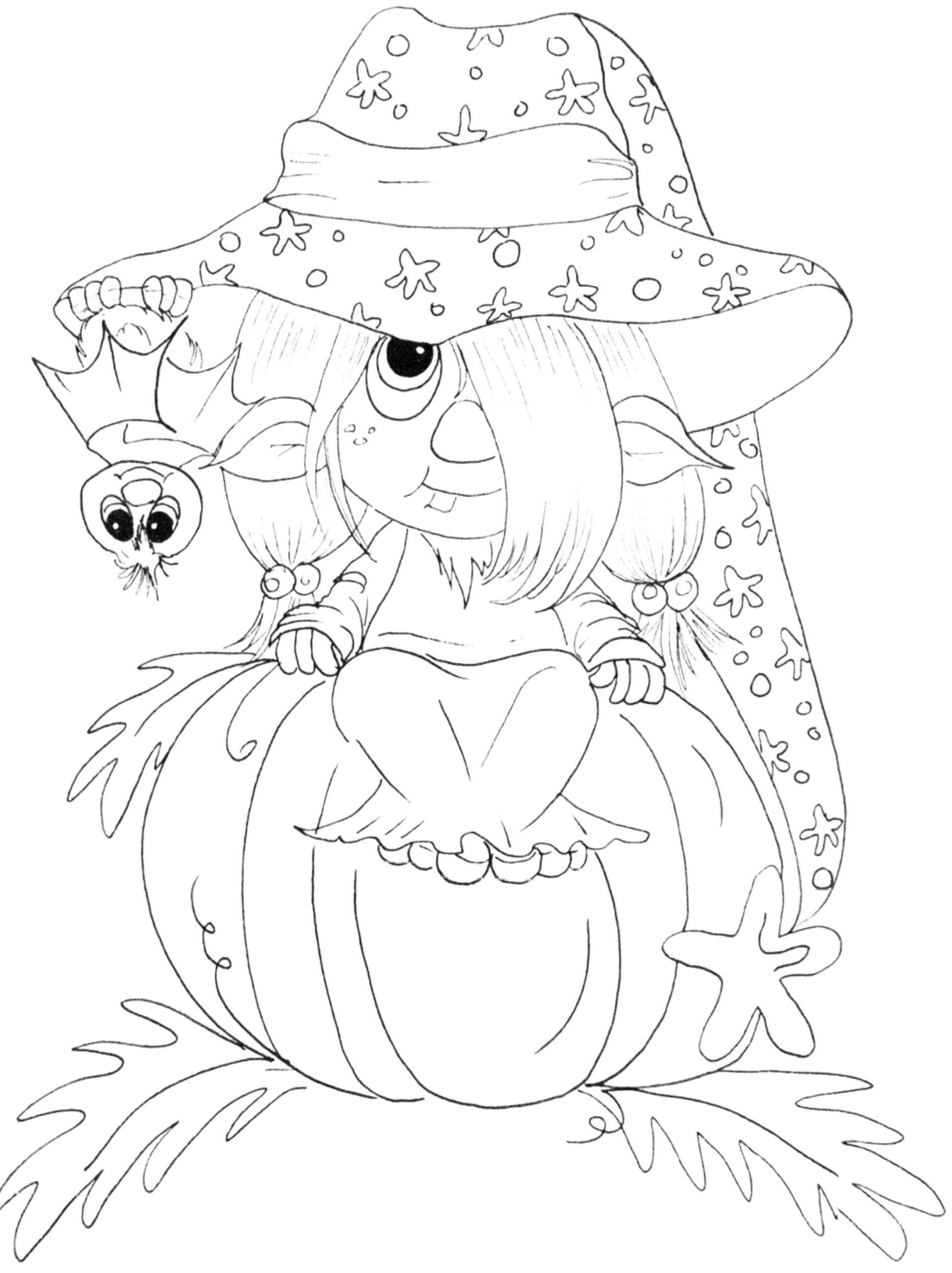

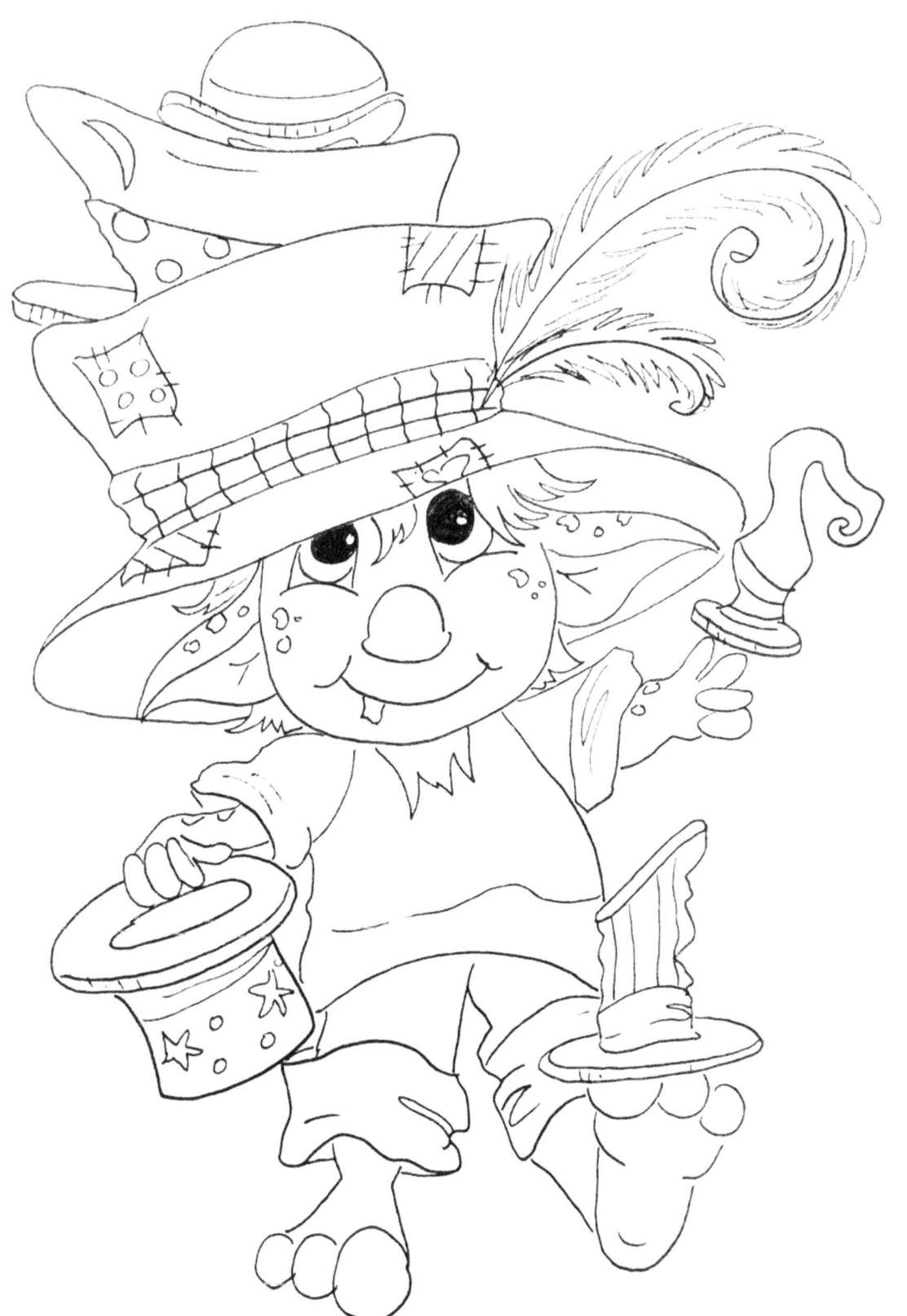

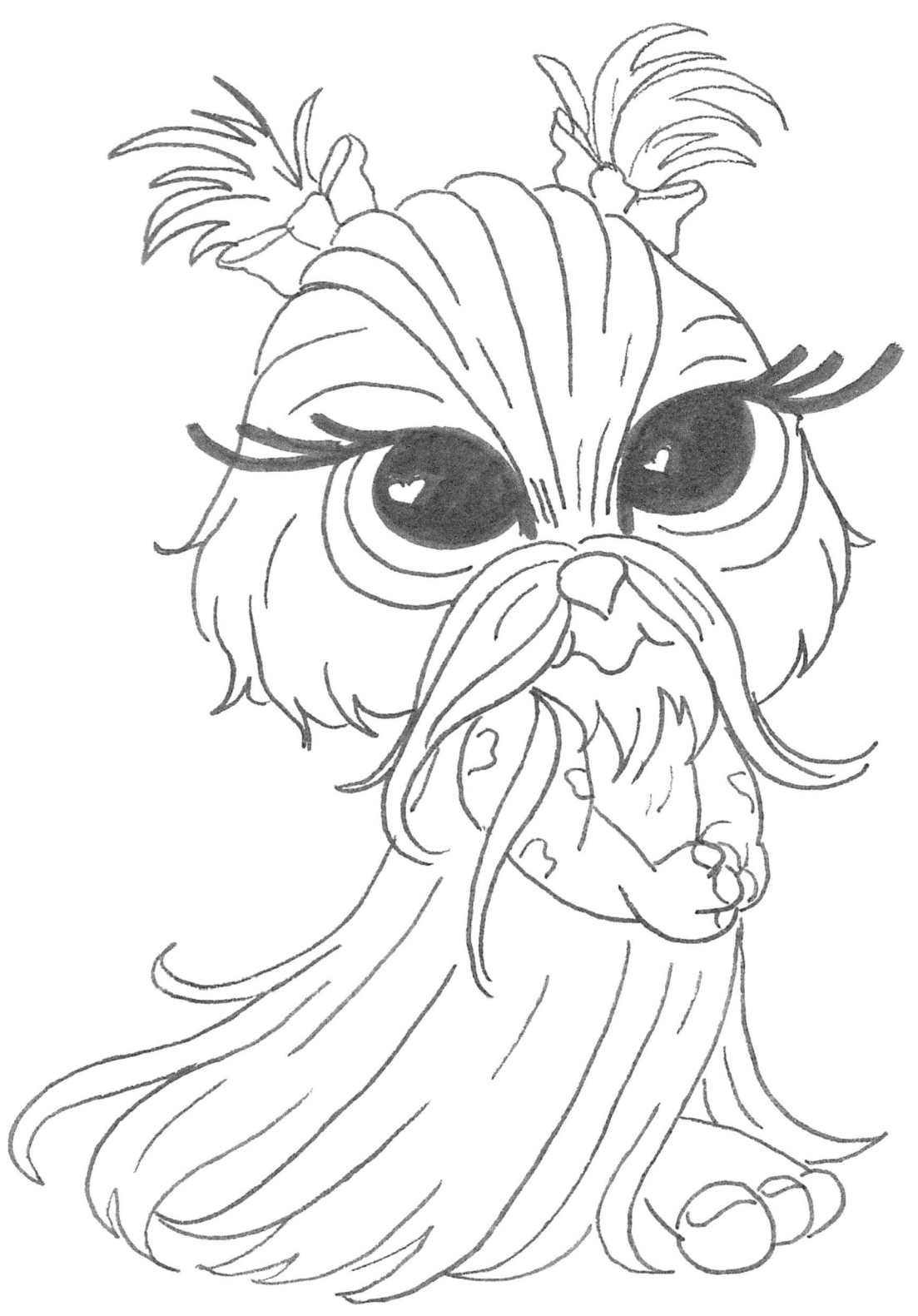

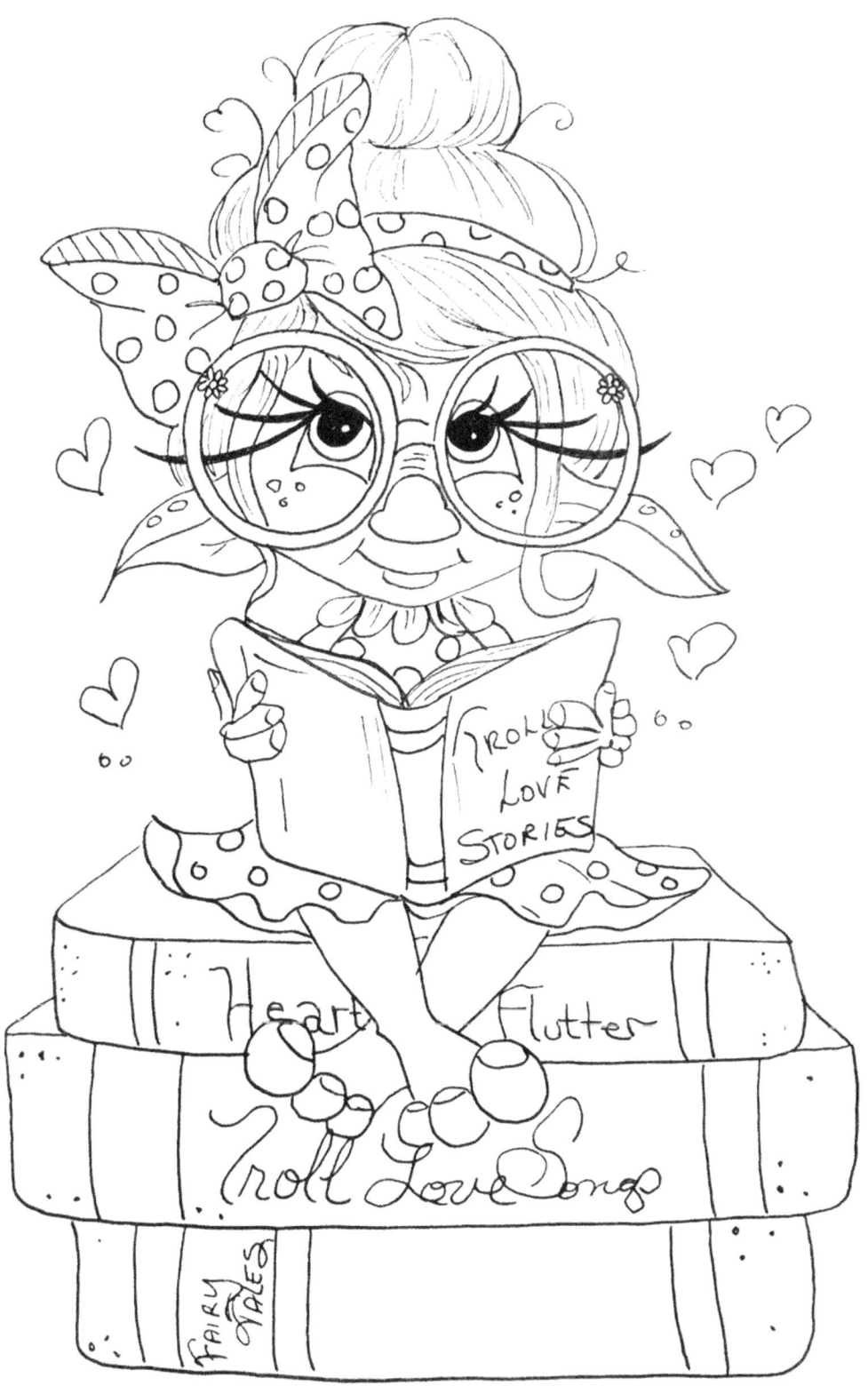

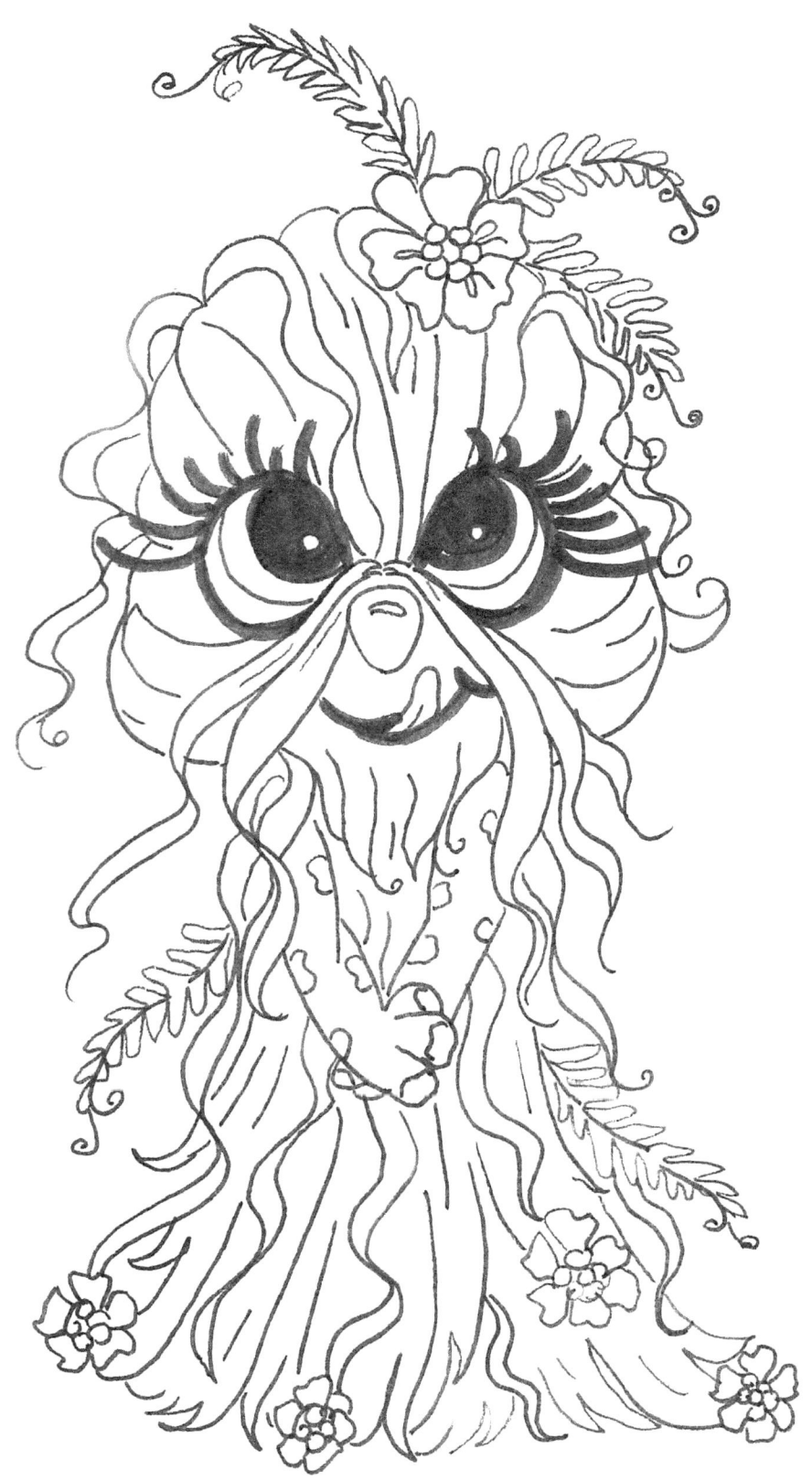

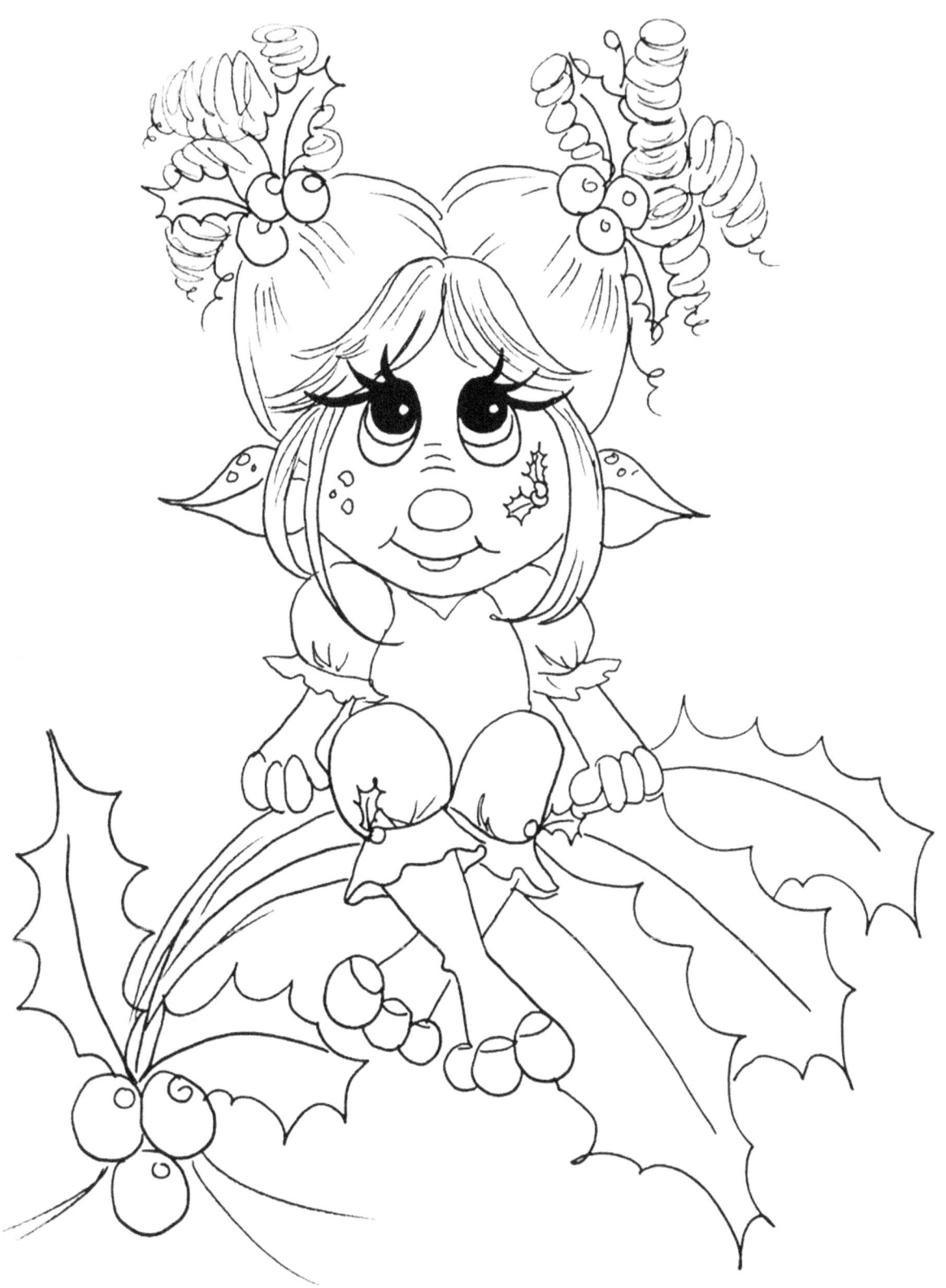

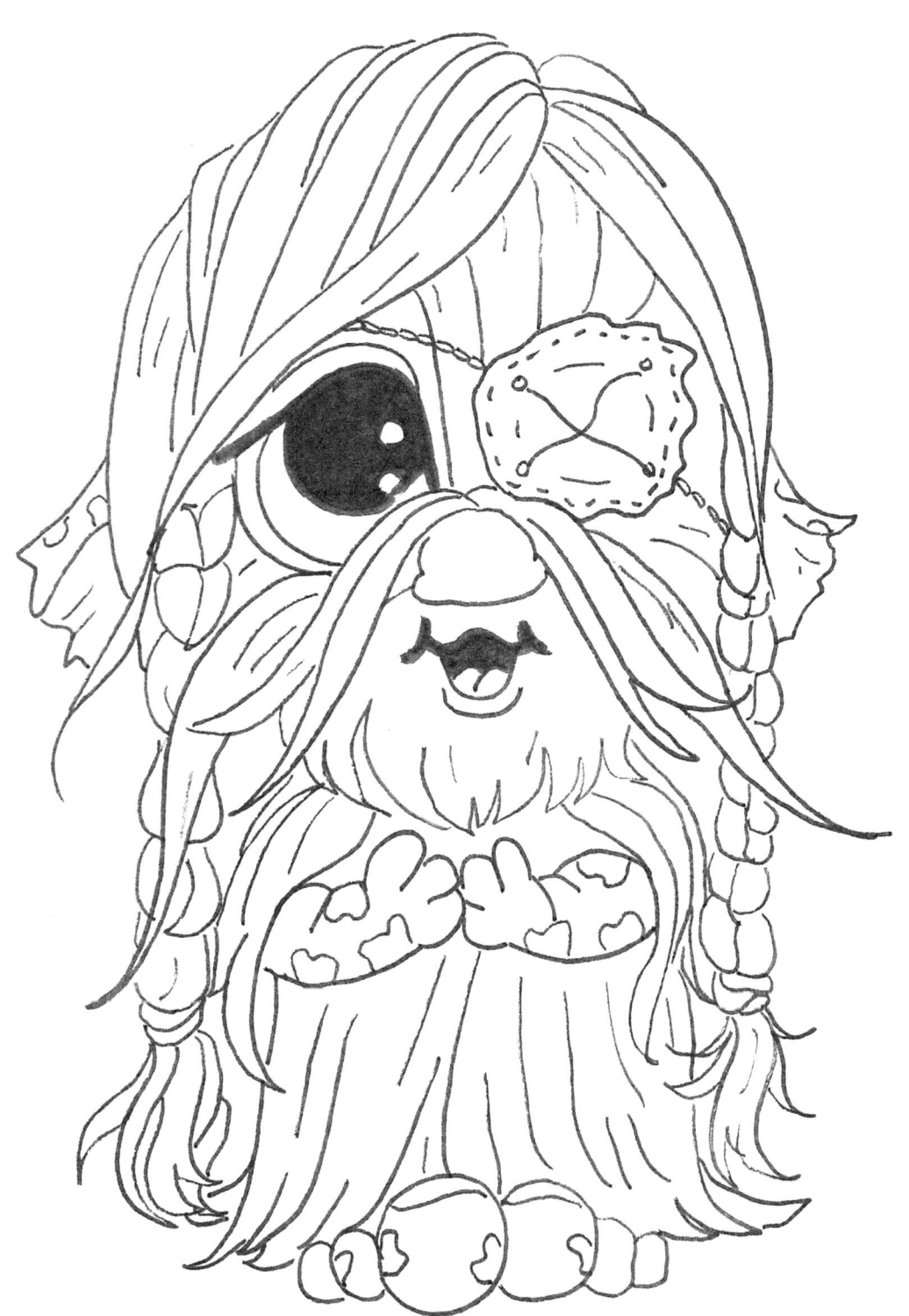

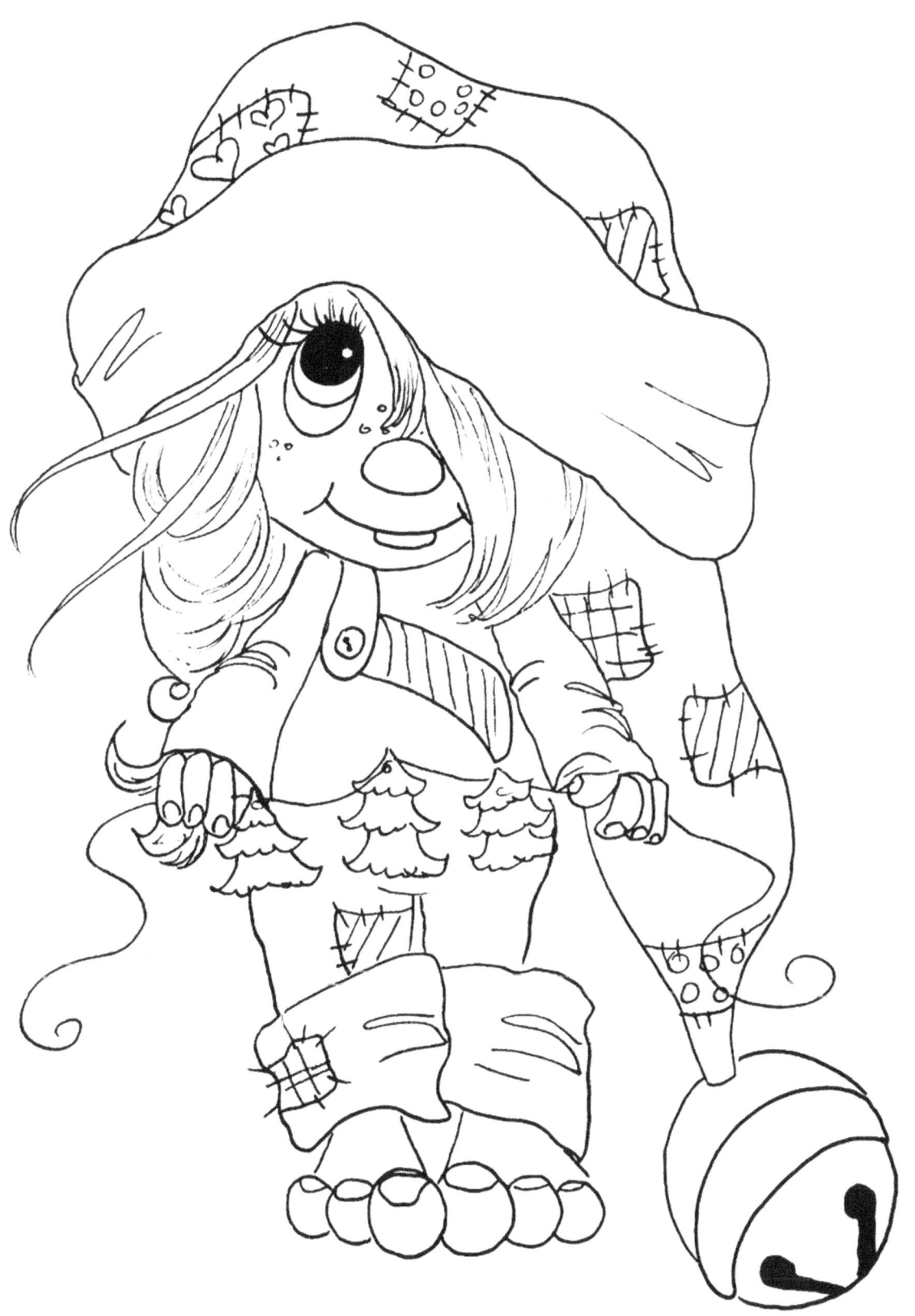

www.ingramcontent.com/pod-product-compliance
Lightning Source LLC
Chambersburg PA
CBHW080543190526
45169CB00007B/2616